MY CELEBRITY BOYFRIEND

MY CELEBRITY BOYFRIEND

LIZA FRANK

BLOOMSBURY

First published in Great Britain 2007

Copyright © 2007 by Liza Frank

The moral right of the author has been asserted

Bloomsbury Publishing Plc, 36 Soho Square, London W1D 3QY

A CIP catalogue record for this book is available
from the British Library

ISBN 0 7475 8158 4
ISBN-13 9780747581581
10 9 8 7 6 5 4 3 2 1

Printed in Singapore by Tien Wah Press

All papers used by Bloomsbury Publishing are natural, recyclable
products made from wood grown in well-managed forests. The
manufacturing processes conform to the environmental
regulations of the country of origin.

www.bloomsbury.com/lizafrank

My name is Liza Frank and I live a glamorous life. When I'm not changing the cat litter and worrying about world peace I ask famous men to pretend to be my boyfriend for a photograph. Why did I choose this path in life? Quite simply, I was dared. And how did I set about all of this? Well, first came the List of Potentials, which grew ever longer as friends heard about the plan and decided to bid for their preferred candidate. The next phase was the calling in of favours, the begging, the bribing with beer, the shameful wheedling and the generally making a nuisance of myself. I decided to enlist the help of everyone I had ever worked with, in fact, everyone I had ever known and had an email address for. Then came the hordes of people who had never actually heard of me but whom I managed to hold on the telephone long enough to convince I was kosher. And then somewhere in the middle of it all I had to start putting my money where my mouth was.

Woke up early going through scenarios. Still haven't done my nails. Glad I packed my bag last night. Need to buy more C41 B&W film. And a fluorie filter. Got ready. Hair – bunches with clips, unsure about hair. Skin – ok-ish, not too spotty, black circles under my eyes, maybe due to the mascara/eyeliner experiment last night, lips good. Missed my train. Felt very underprepared. Have no idea what to expect. Forgotten the rules of flash again.

And so it began. But with all relationships there were rules:

I) the Boyfriend was in control of the shoot – he chose the time, the location and the pose

2) unless the Boyfriend requested otherwise, I'd always be in black and denim

3) I'd never pretend it was for real and try to sell the photos to a tabloid

He was under strict orders from his wife that there was to be no smooching.

So, armed with my trusty SLR, a couple more cameras (for safety), lots of equipment that I never actually used, my diary, a small nail file and some mints, I went forth and got on to trains, drove up motorways, panicked on rollercoasters, broke down on barges, had breakfasts, lunches, dinners, coffees, teas, drinks, dressed up, dressed down, got cold, got hot, got cramp, got hysterical and got really, really embarrassed.

So we took our tops off and I pulled down my vest and bra straps and then halfway through the shoot the door opened and his mate walked in. And suddenly it became like a Carry On film.

And of course I was always totally professional in all aspects of my work.

He was so pretty that I acted like a tongue-tied moron. He kept telling me what a good idea it all was and all I could do was stare and maybe drool a little. I'm a disgrace.

And then one day I woke up and realised that I'd won the dare. I had met childhood heroes and teenage lusts. I had worn the same clothes for three years. But had I actually learnt anything on this journey?
Hell yes:

Always wear a vest – great for cold winter days and practical for all those times it's suggested that you pretend to go naked in public places.
He suggested we try one in the car park and I thanked my lucky stars it wasn't snowing again.

Never underestimate your date.
It was then he revealed he was wearing a golden codpiece.

Always carry mints – a thoughtful touch if you've had a remarkable amount of garlic the night before.
Tried really hard not to breathe on him as no amount of brushing had eradicated the taste of the chilli.

It's pointless getting embarrassed – leave vanity at the door.
I just can't pull off fishnets.

And lastly, never confuse fantasy with reality.
Well that was quite surreal, Jesus took the photograph.

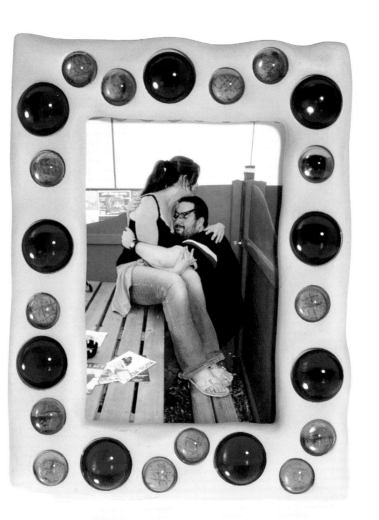

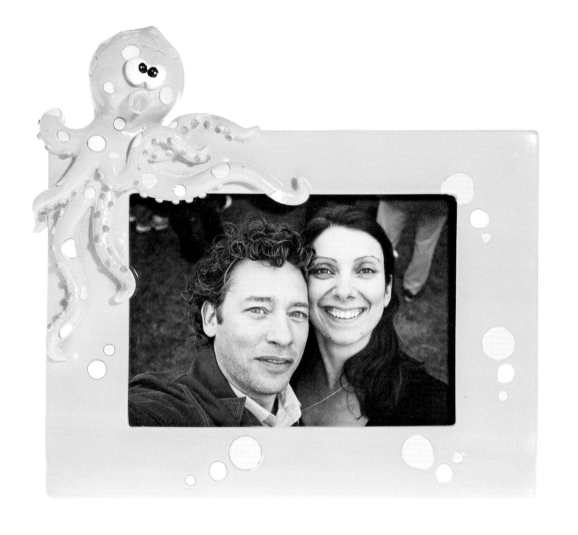

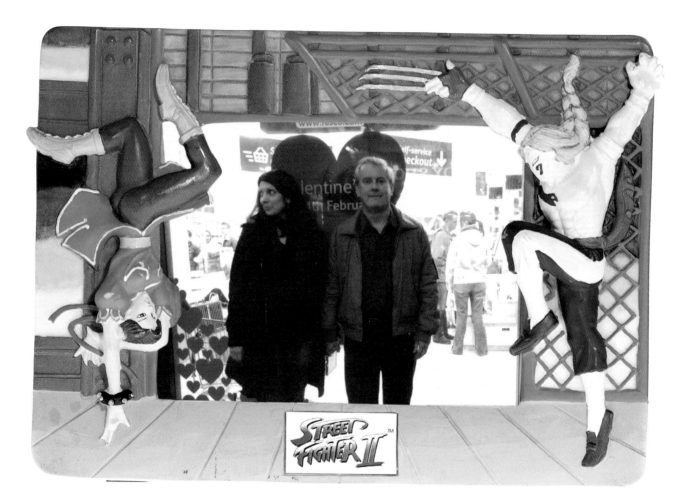

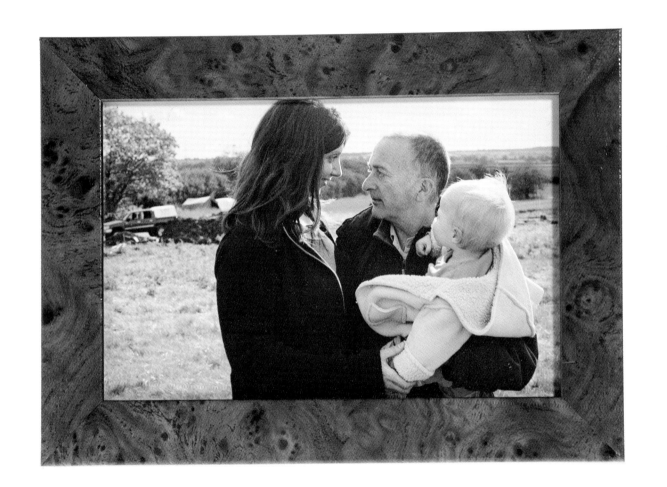

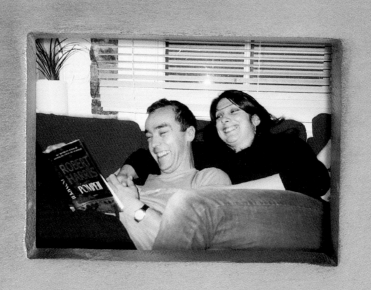

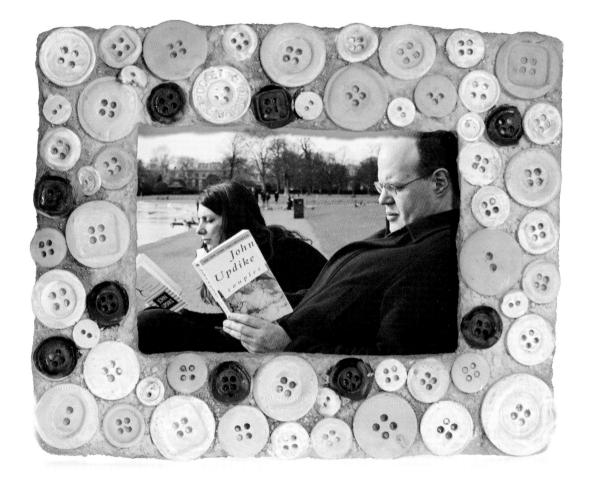

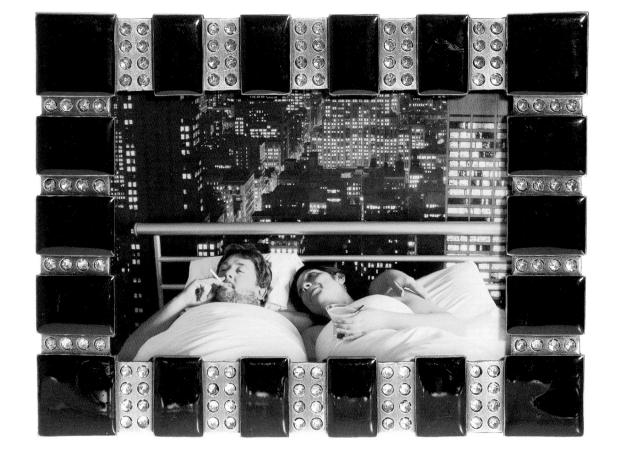

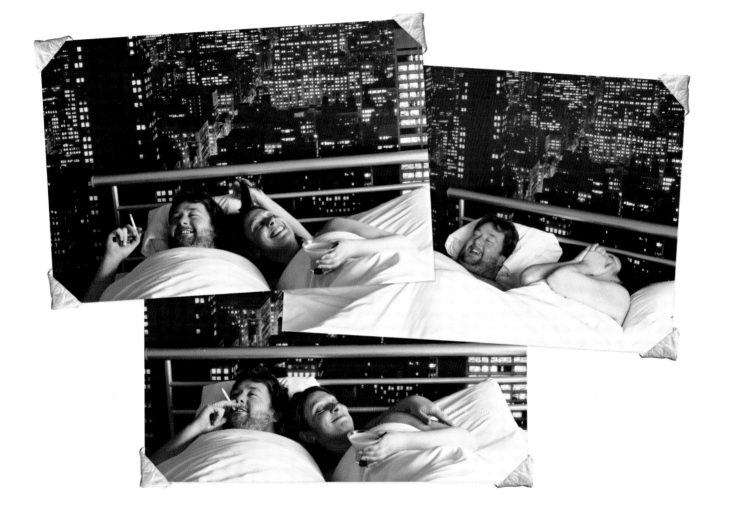

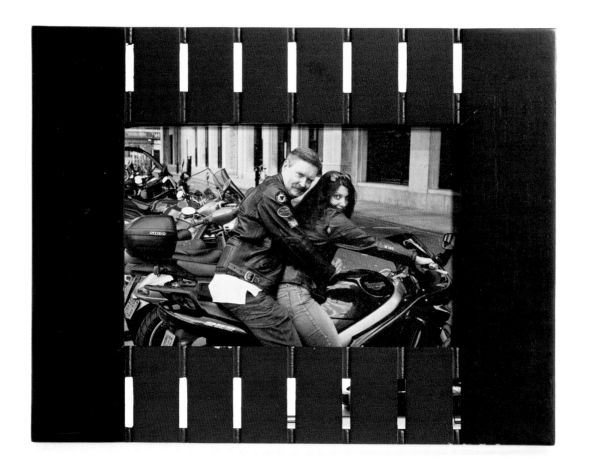

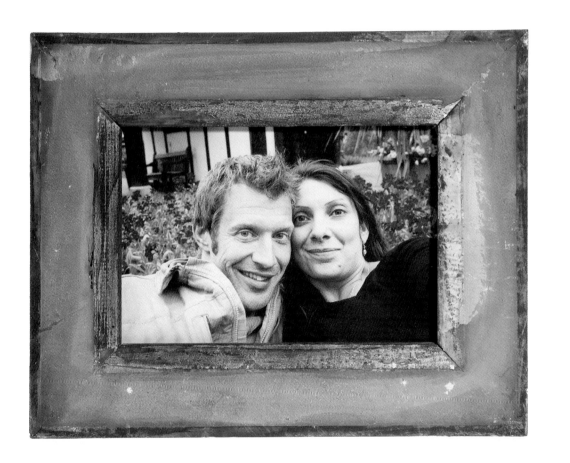

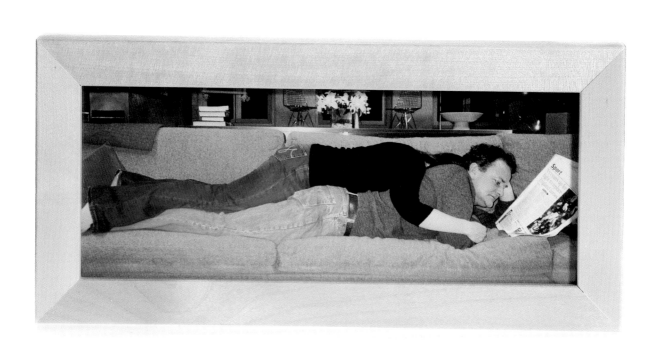

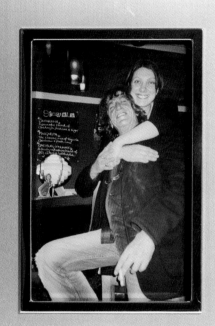

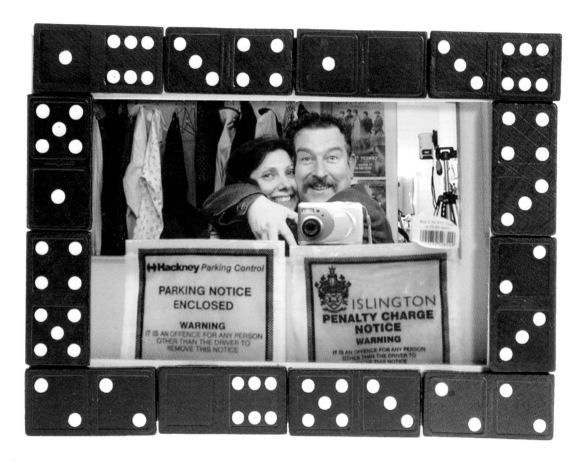

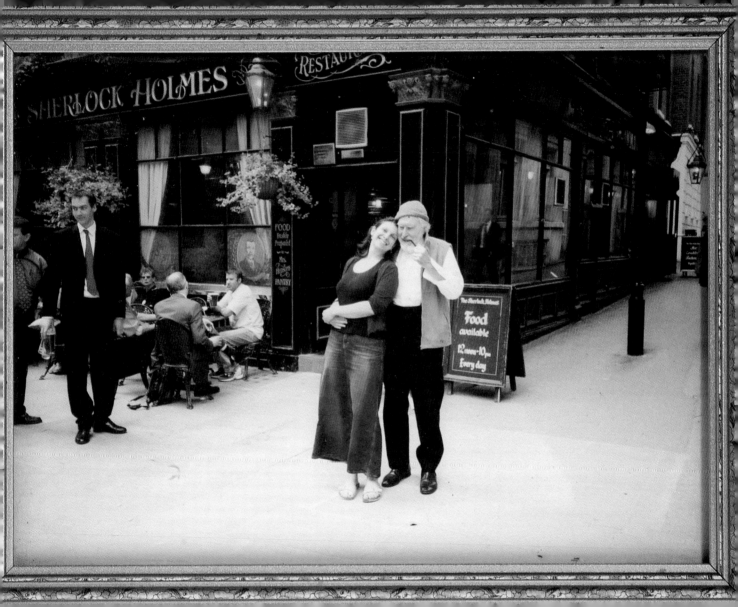

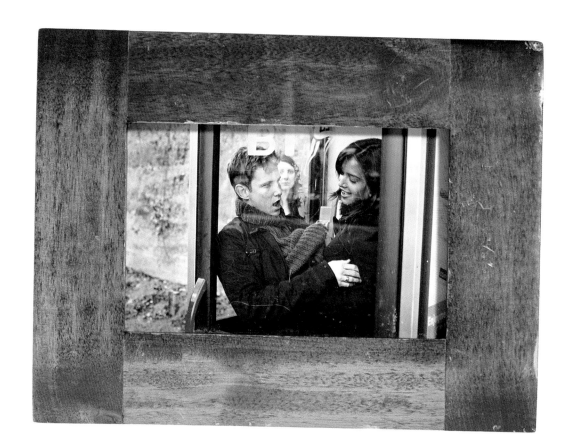

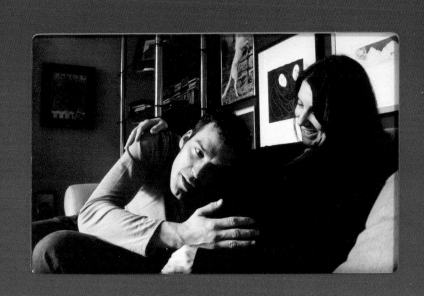

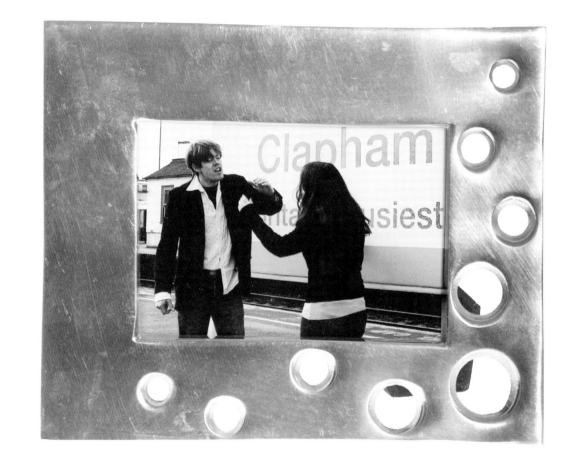

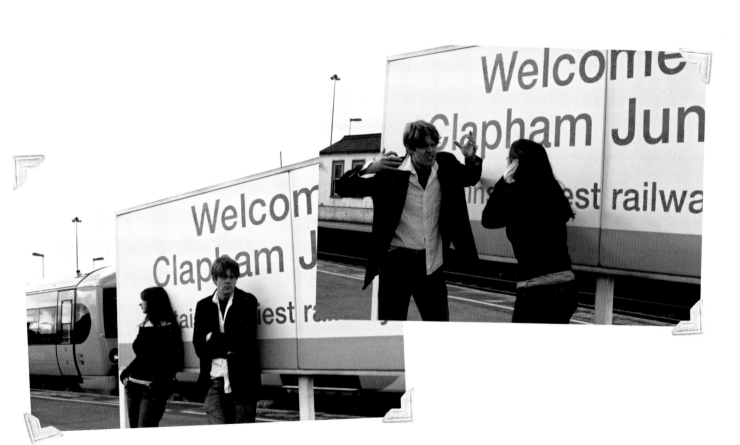

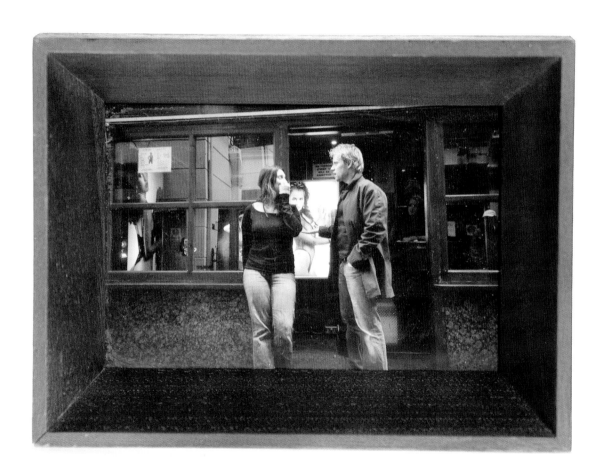

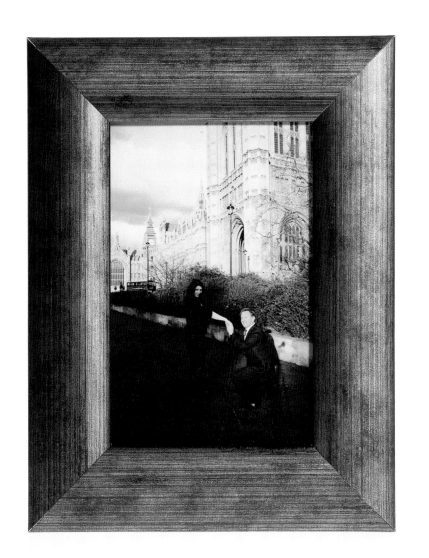

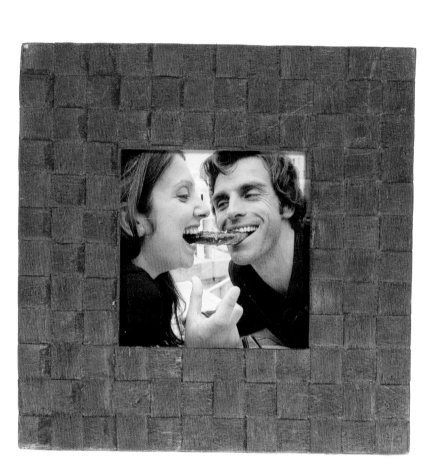

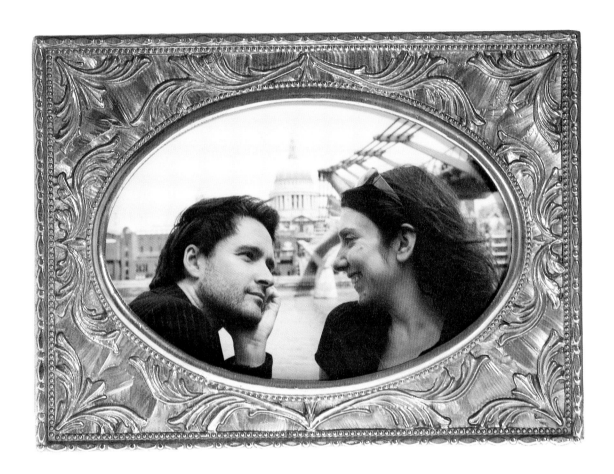

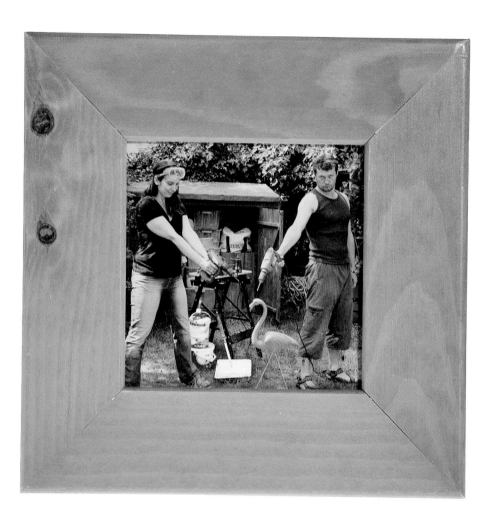

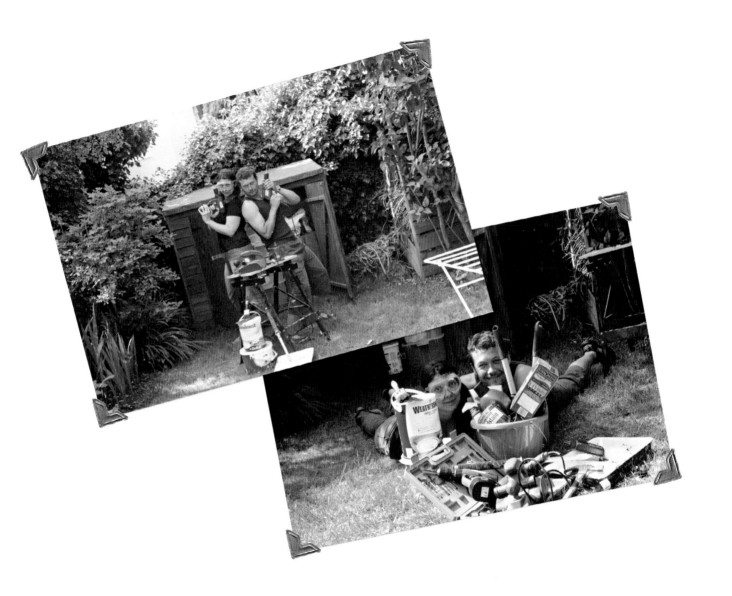

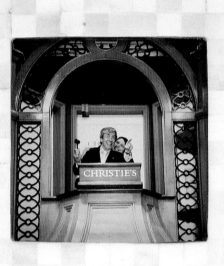

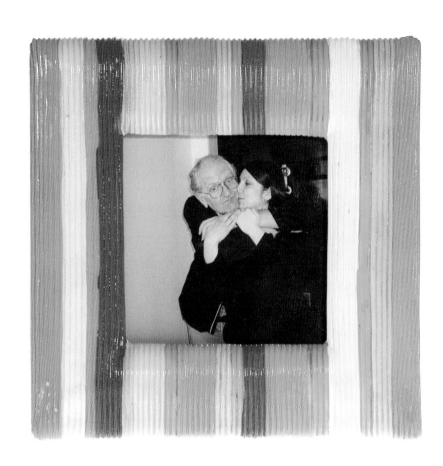

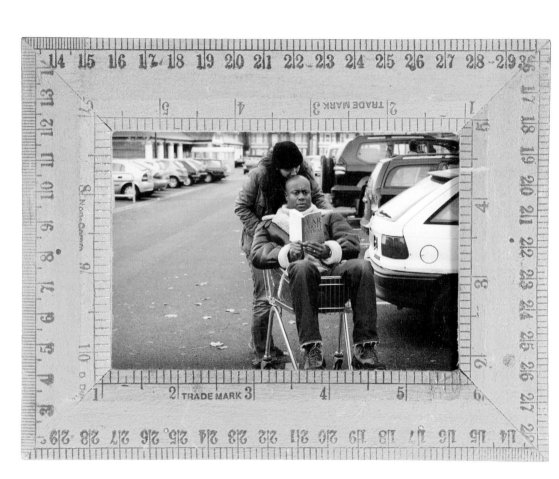

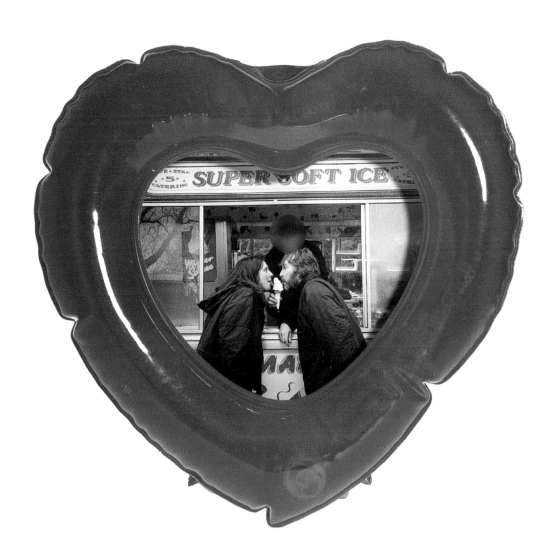

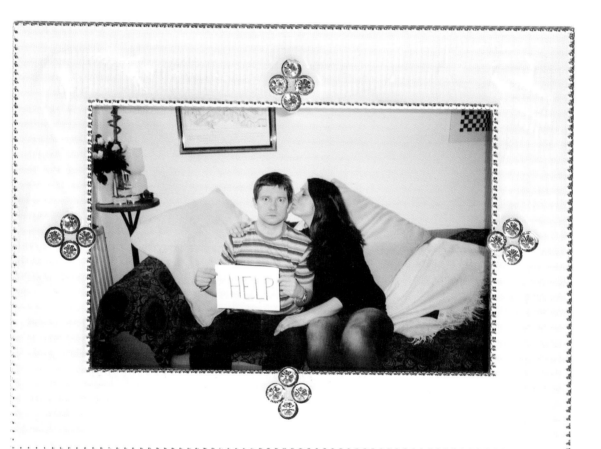

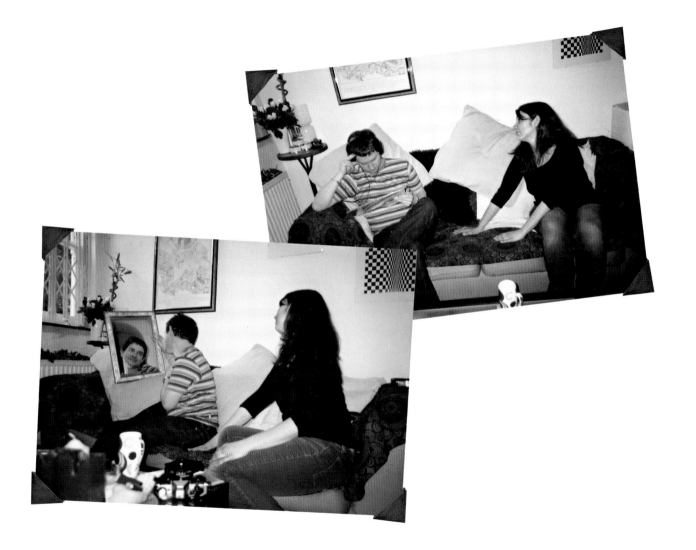

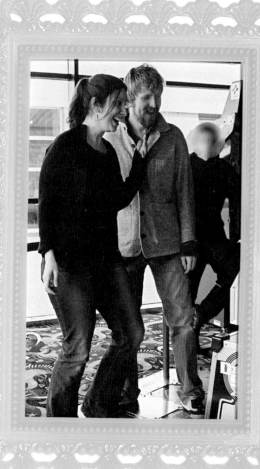

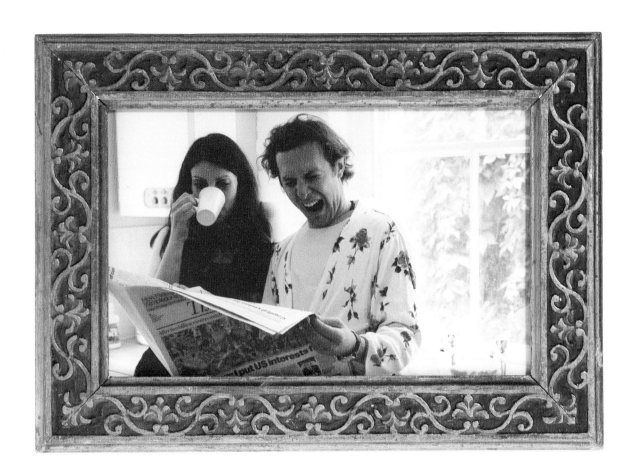

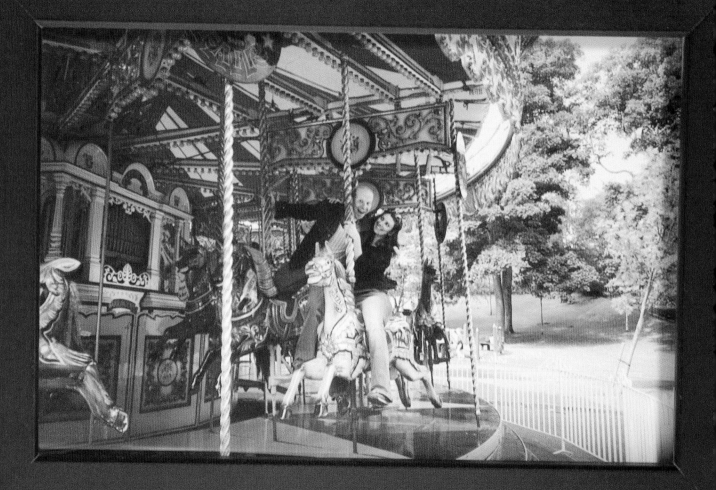

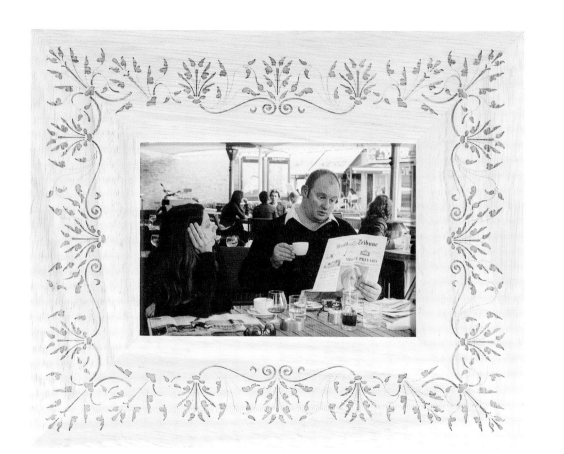

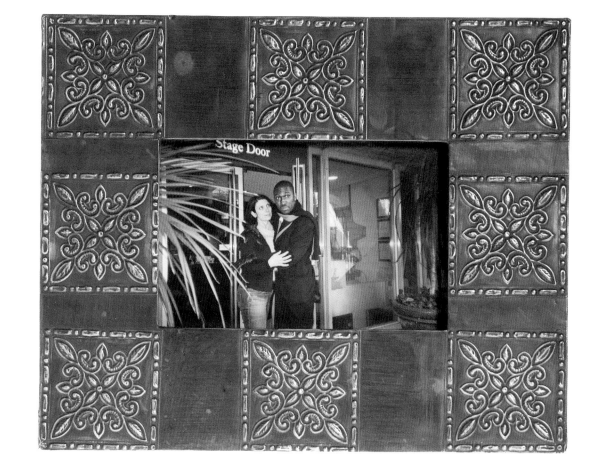

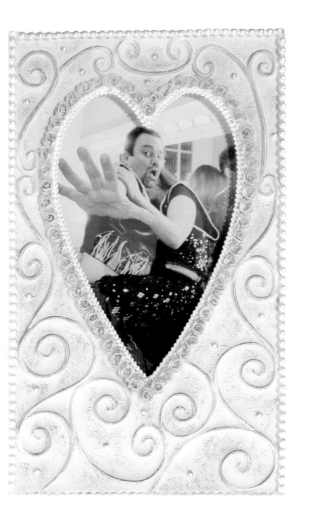

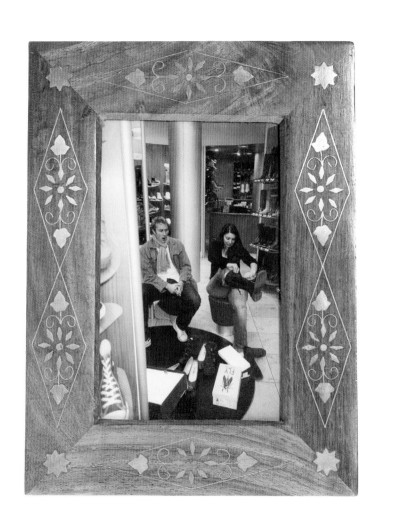

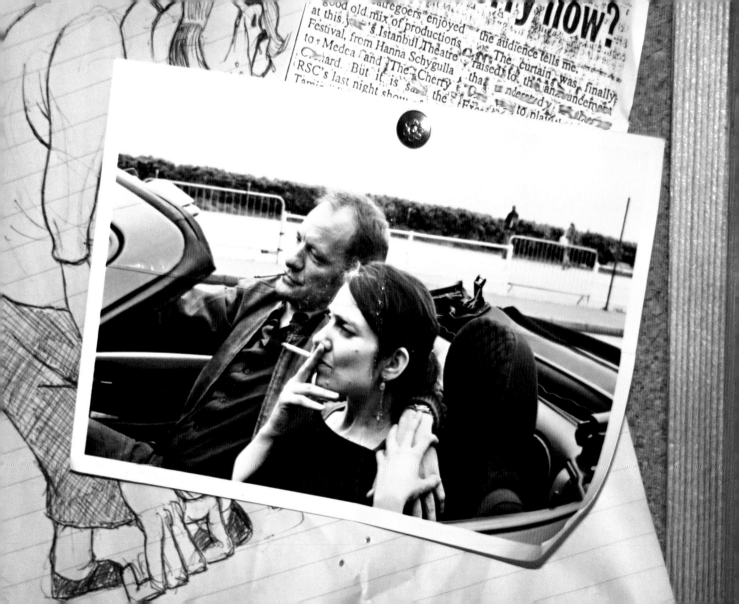

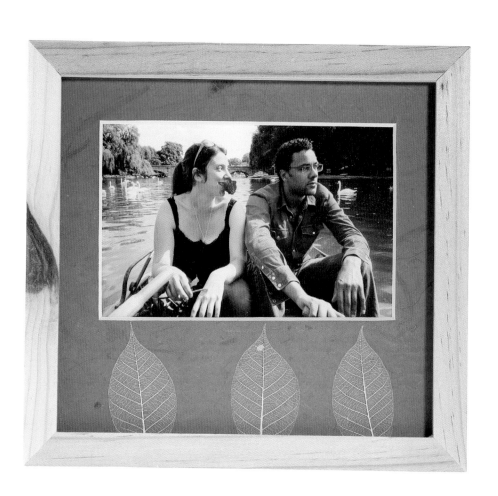

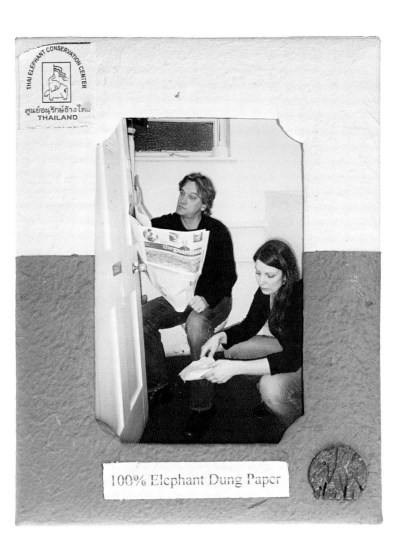

100% Elephant Dung Paper

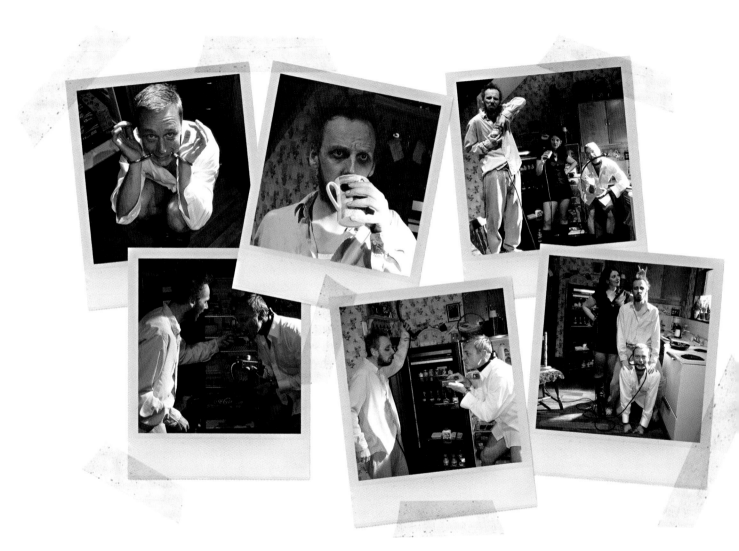

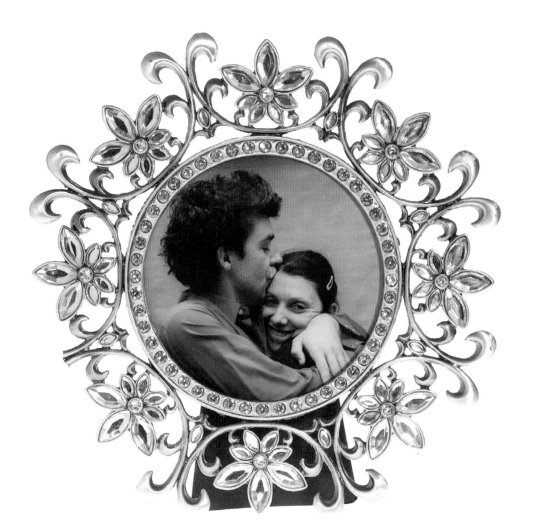

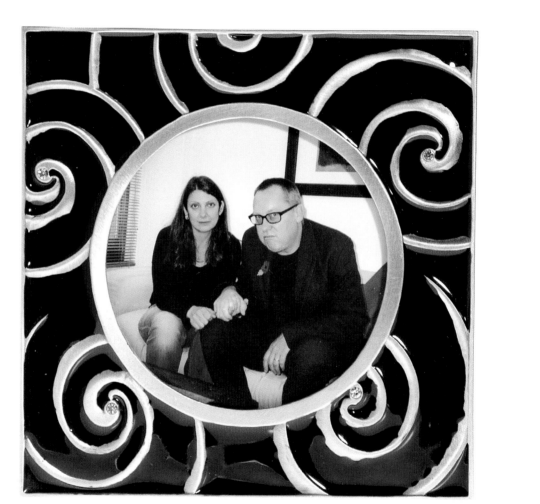

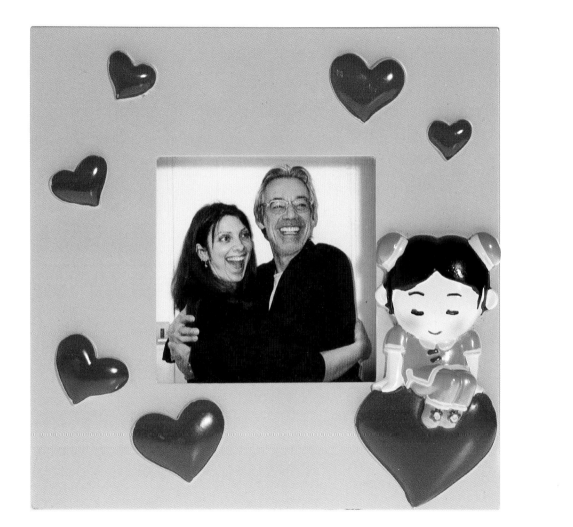

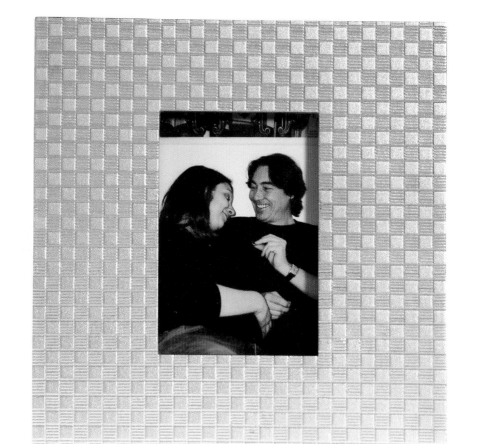

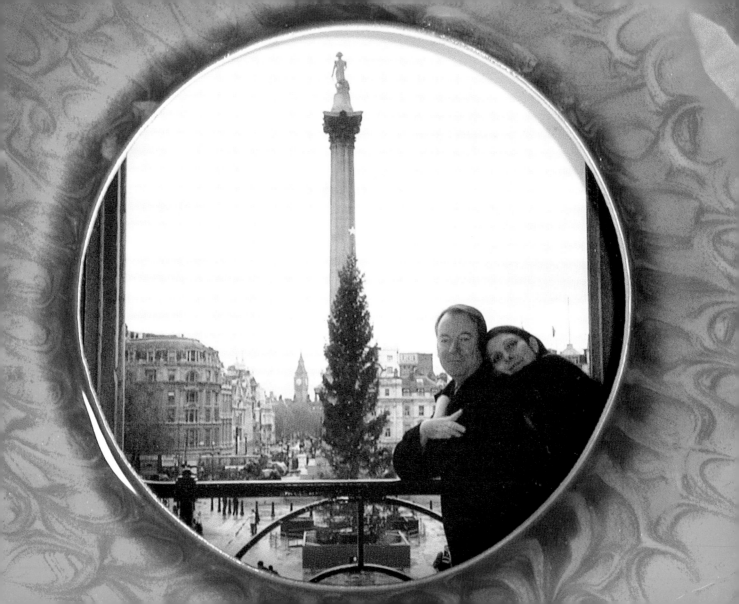

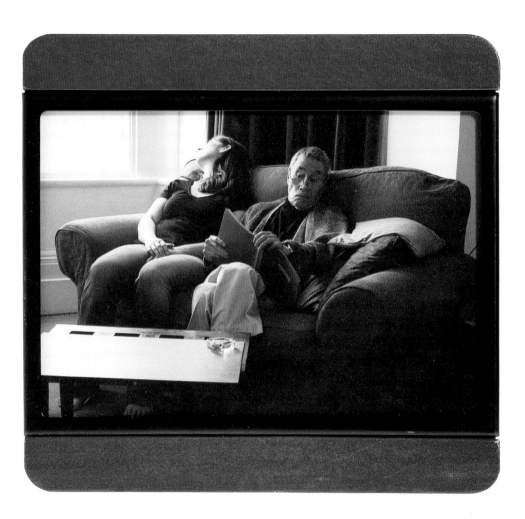

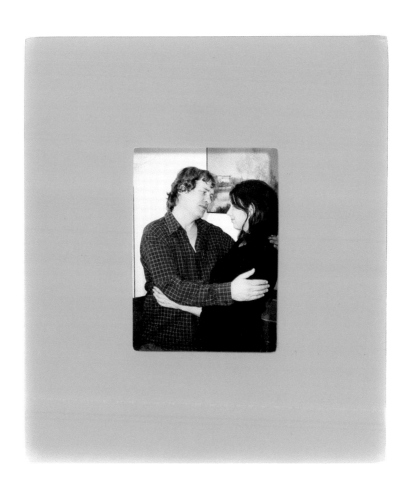

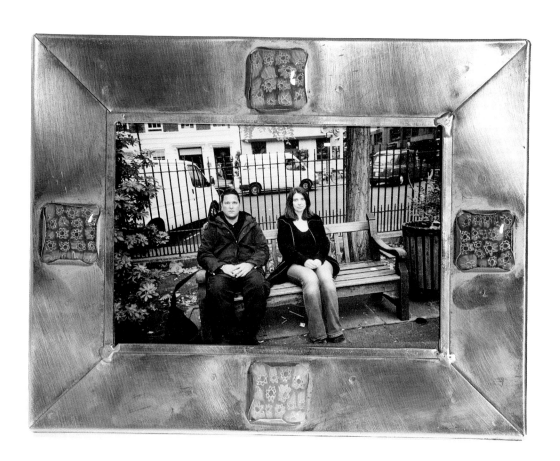

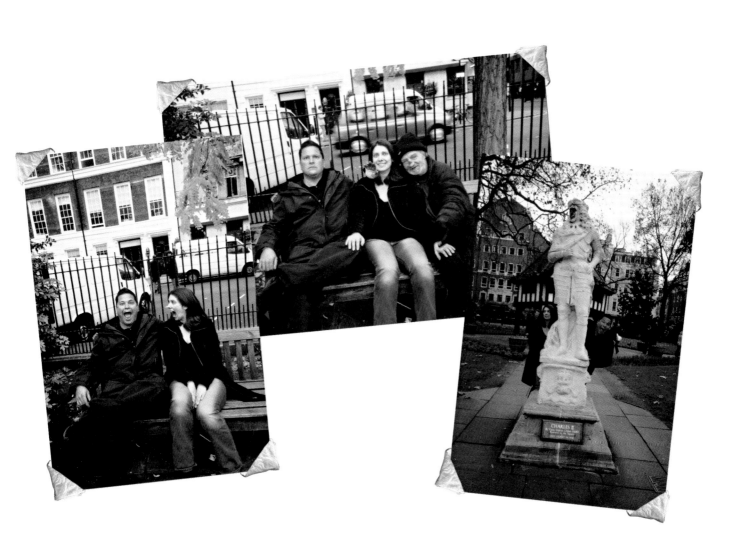

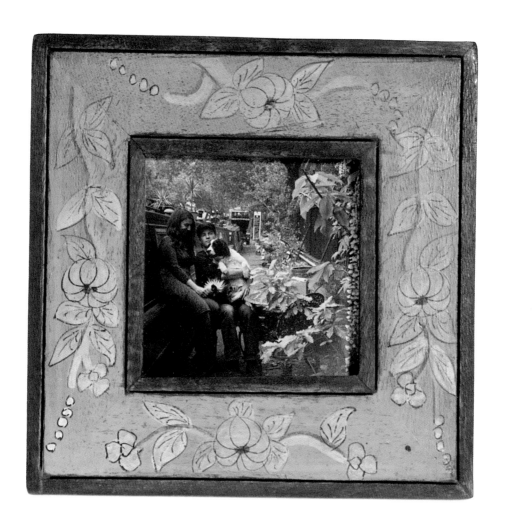

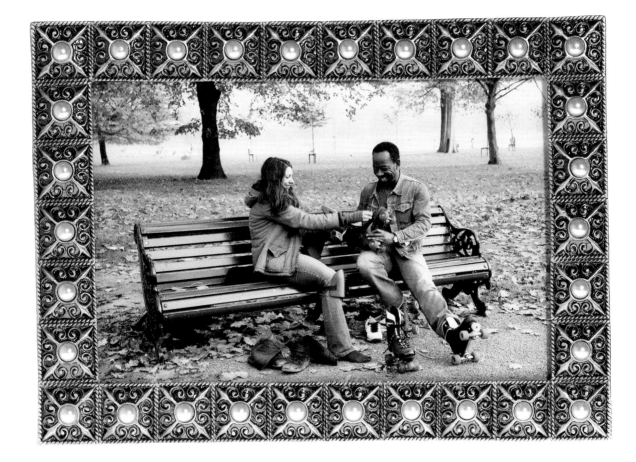

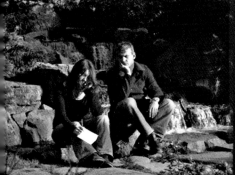 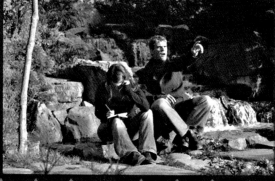 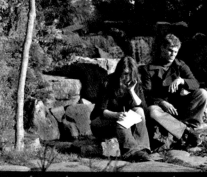

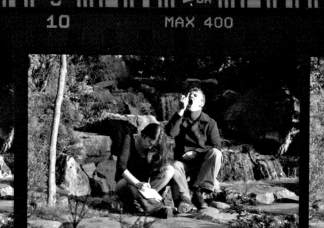 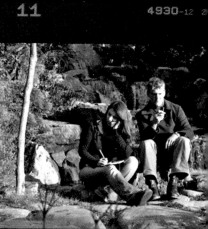

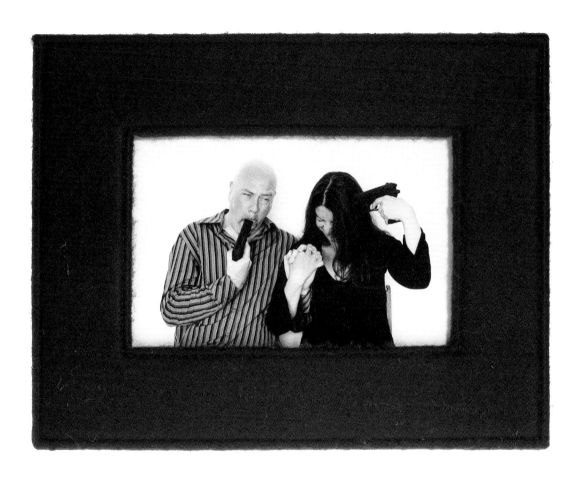

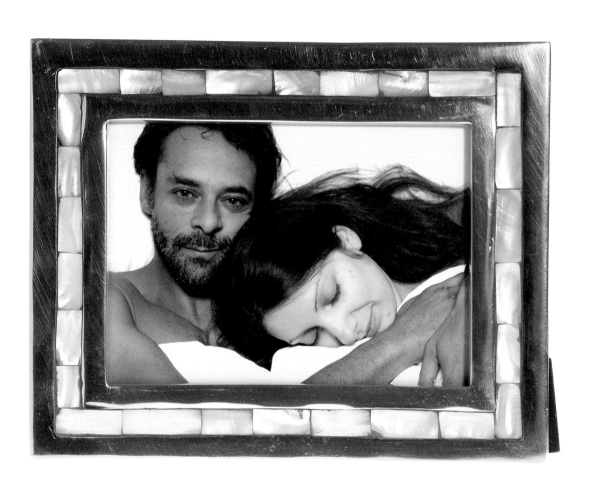

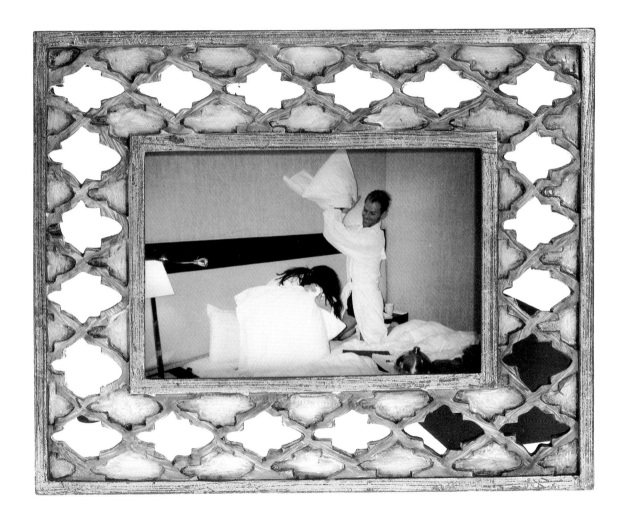

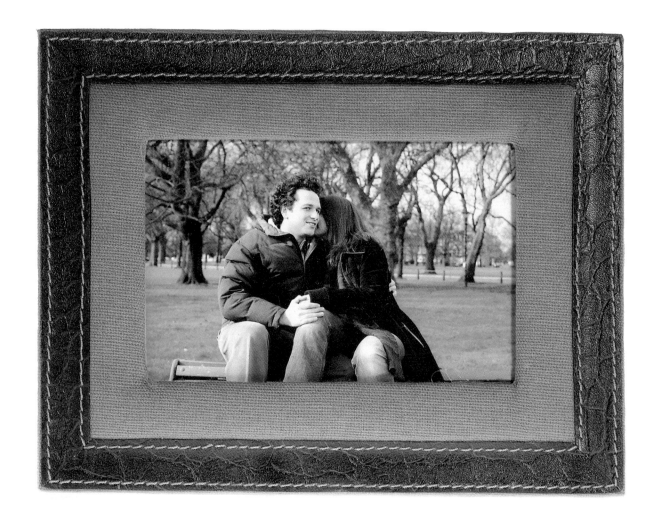

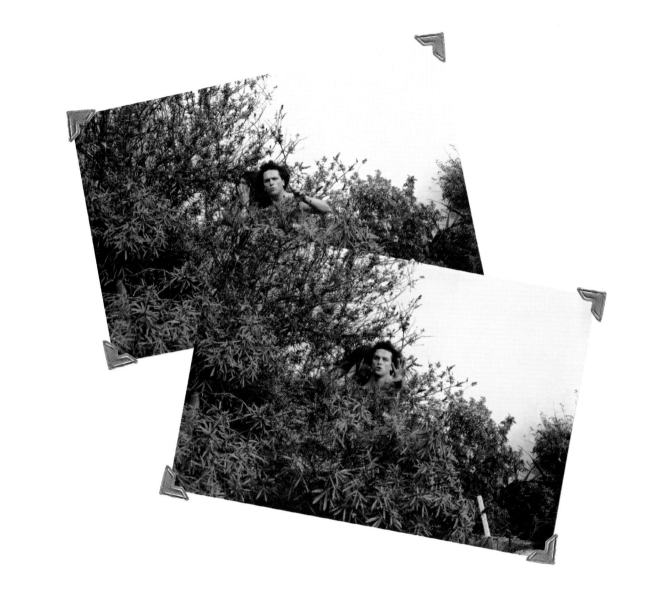

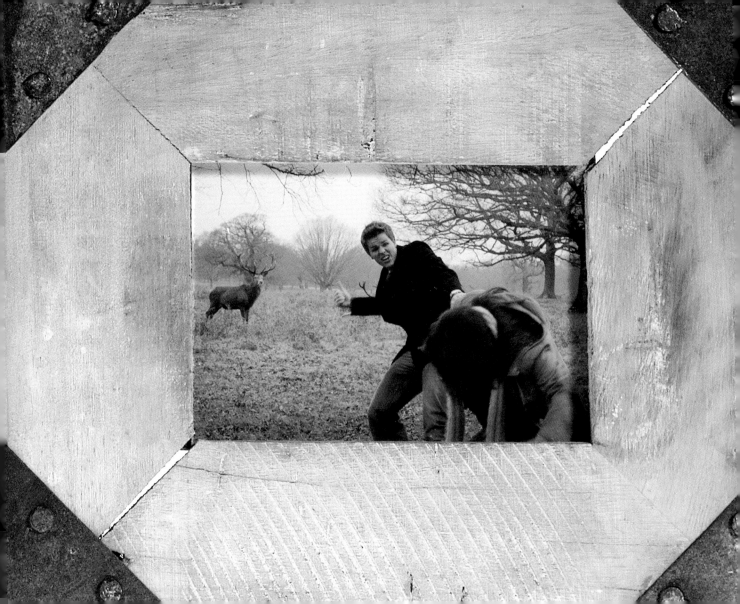

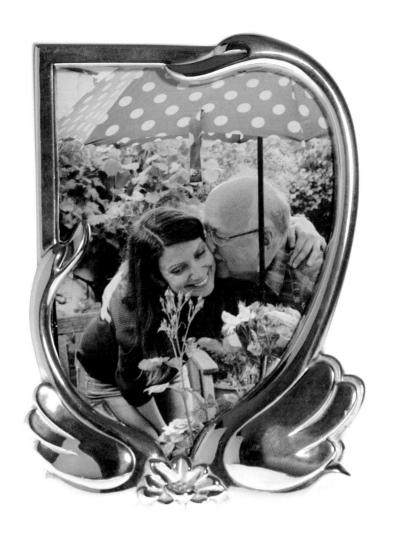

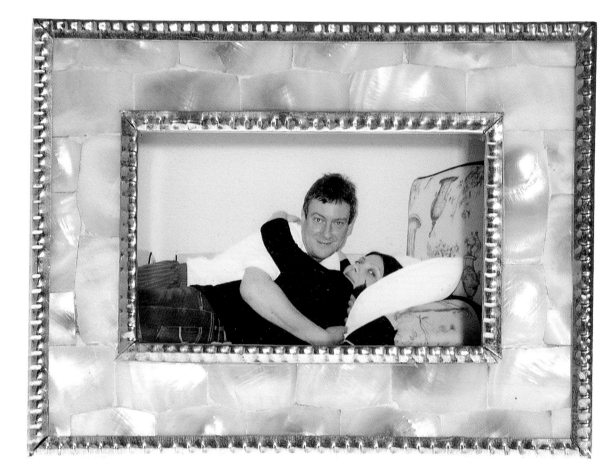

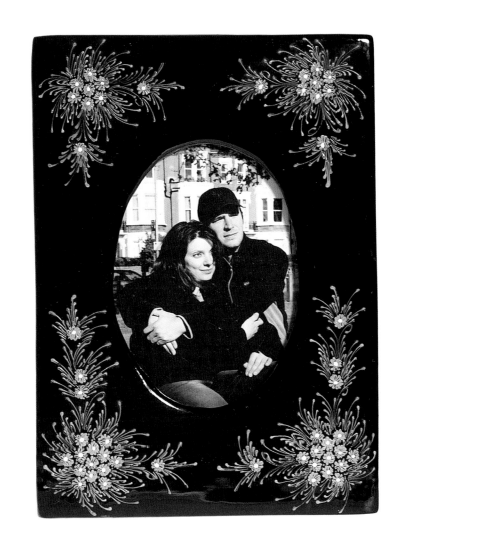

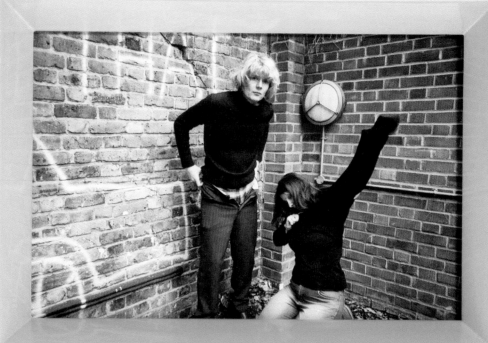

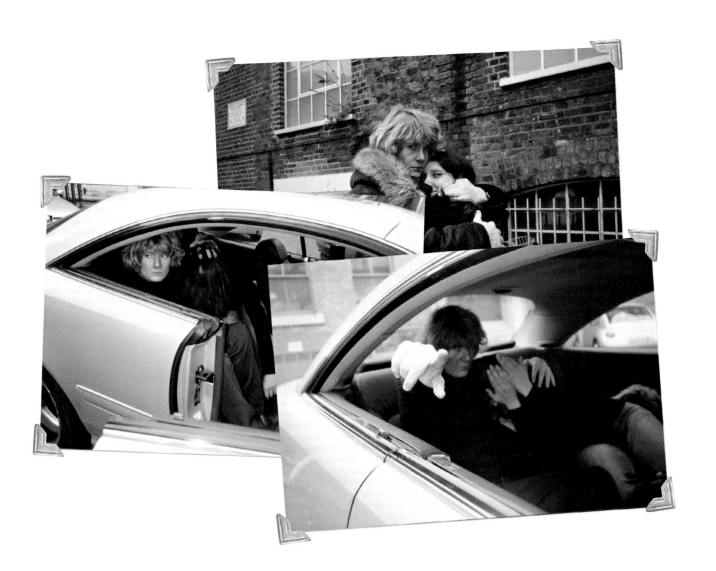

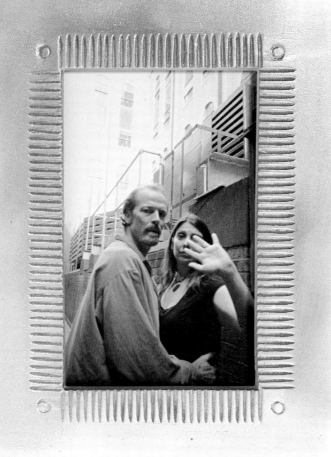

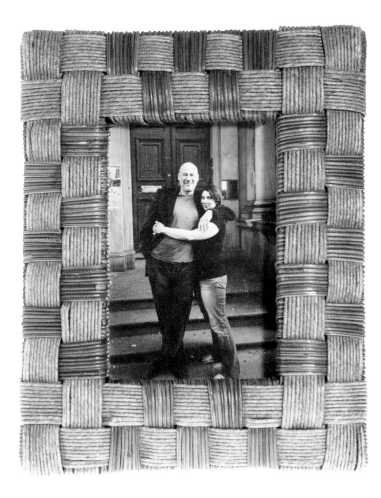

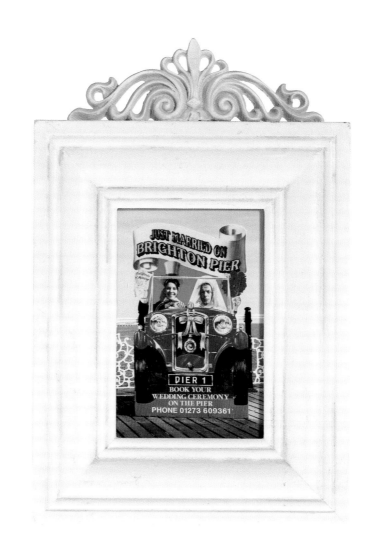

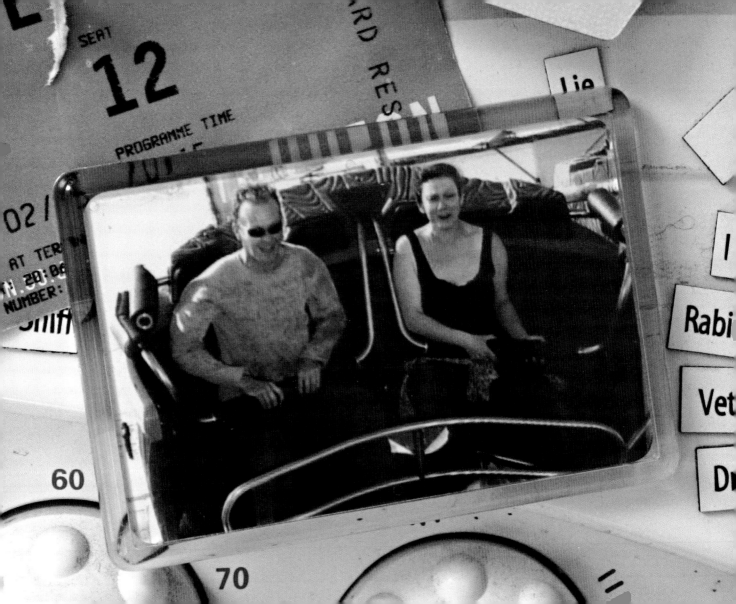

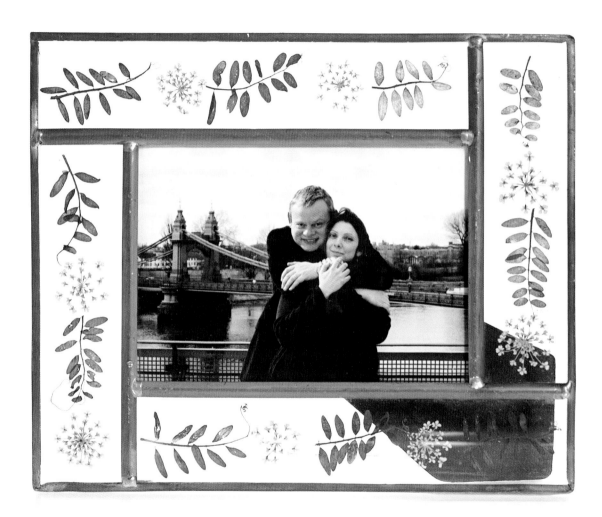

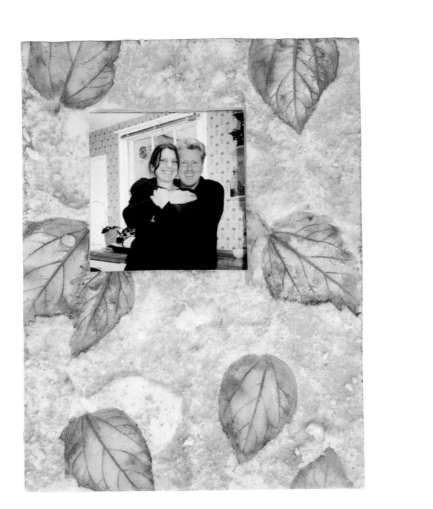

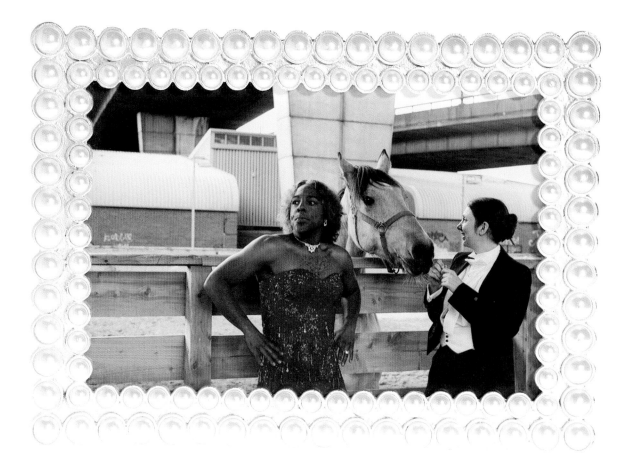

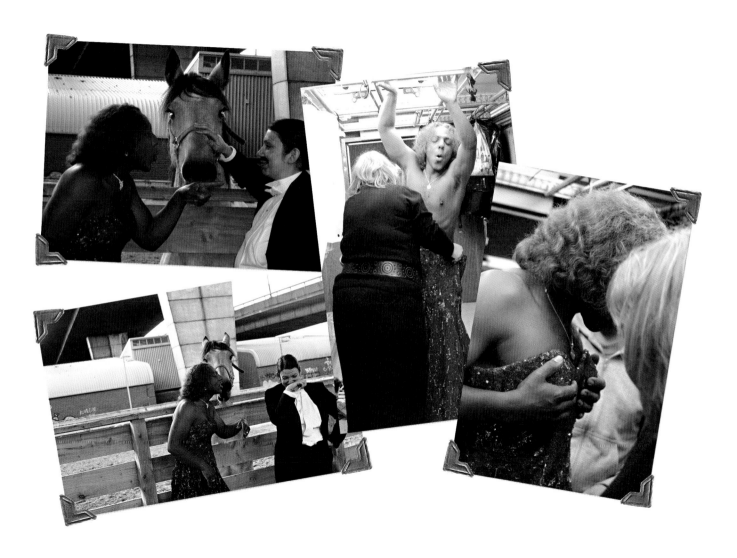

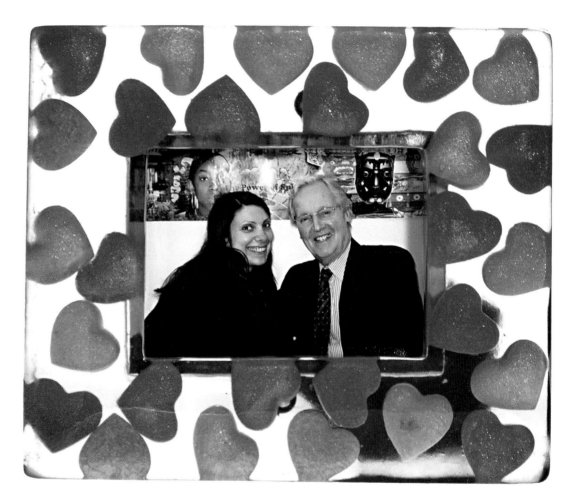

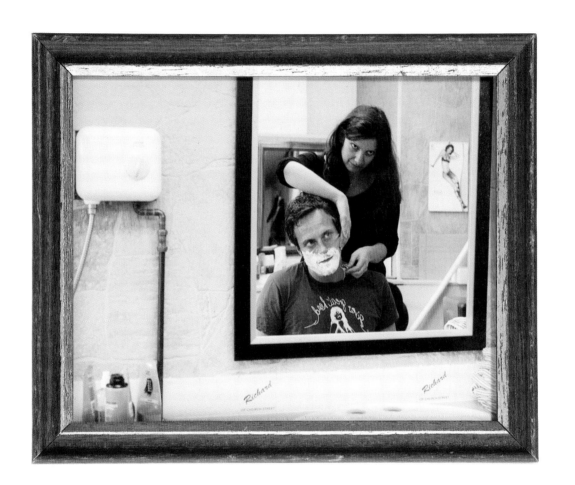

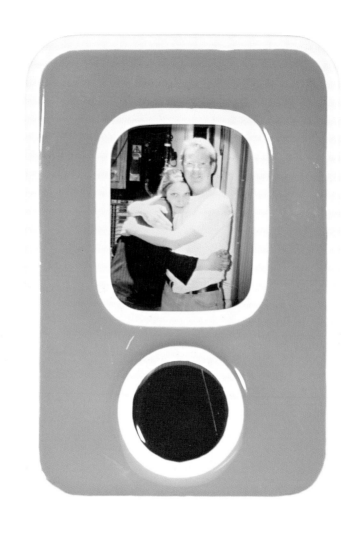

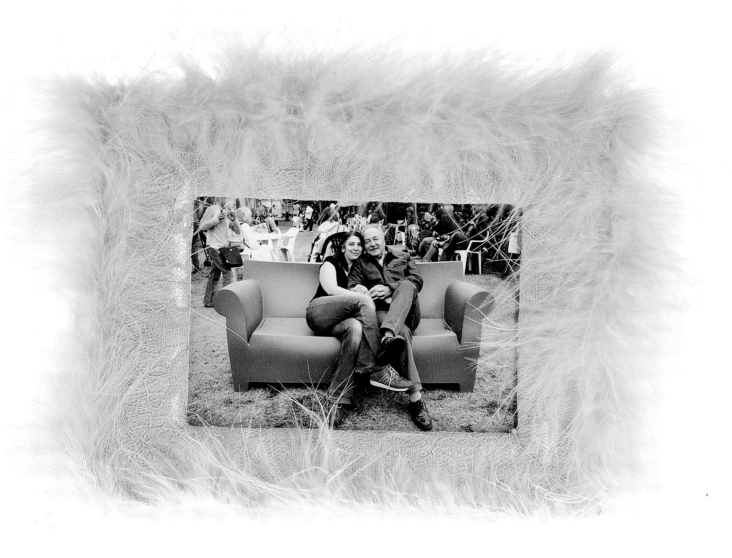

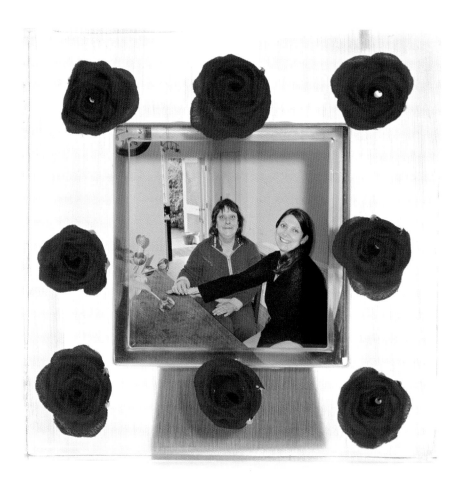

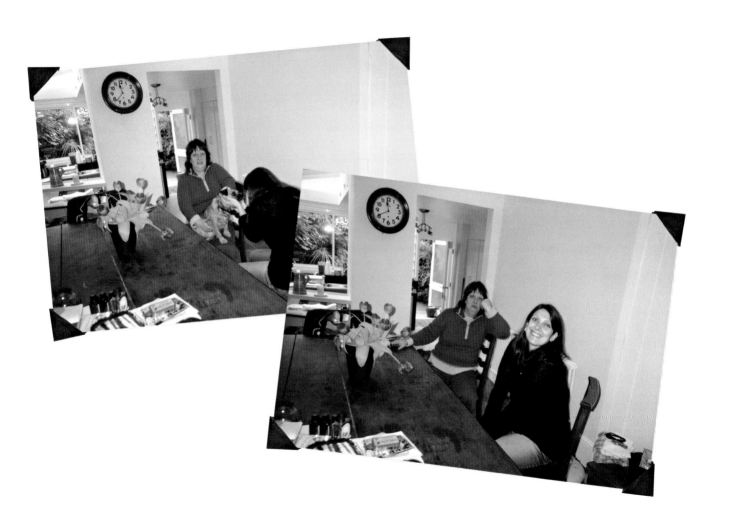

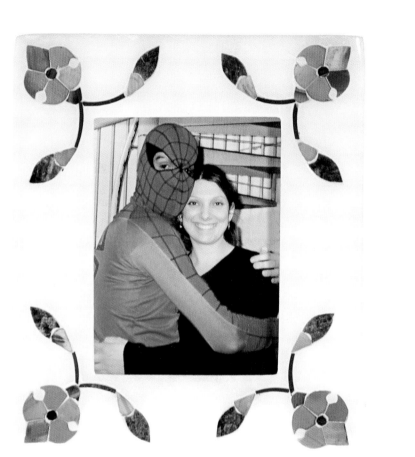

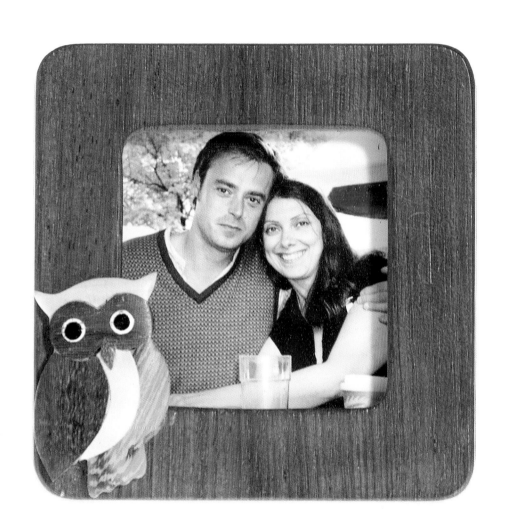

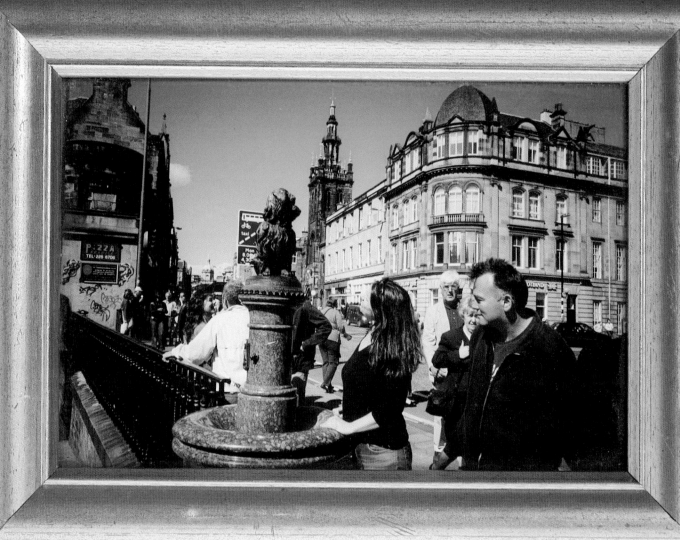

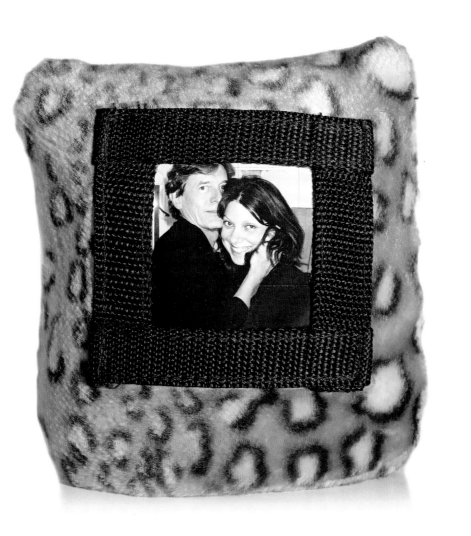

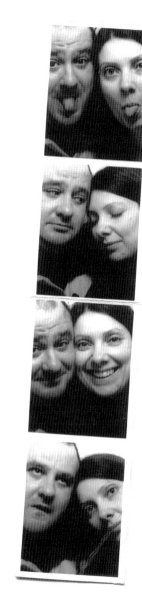

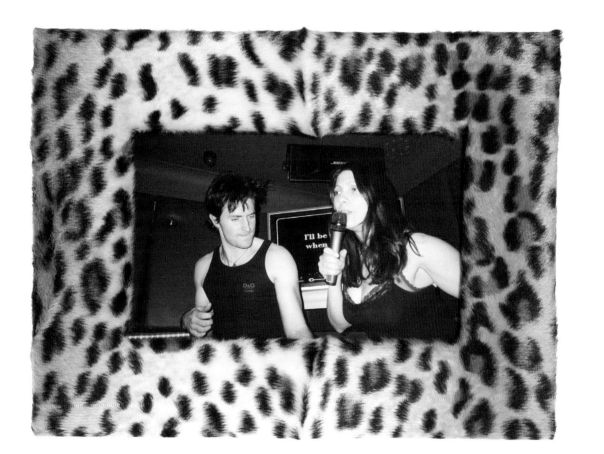

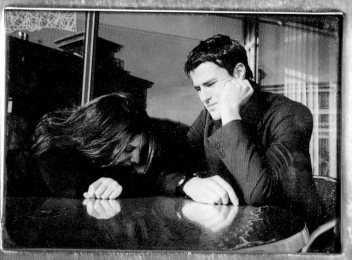

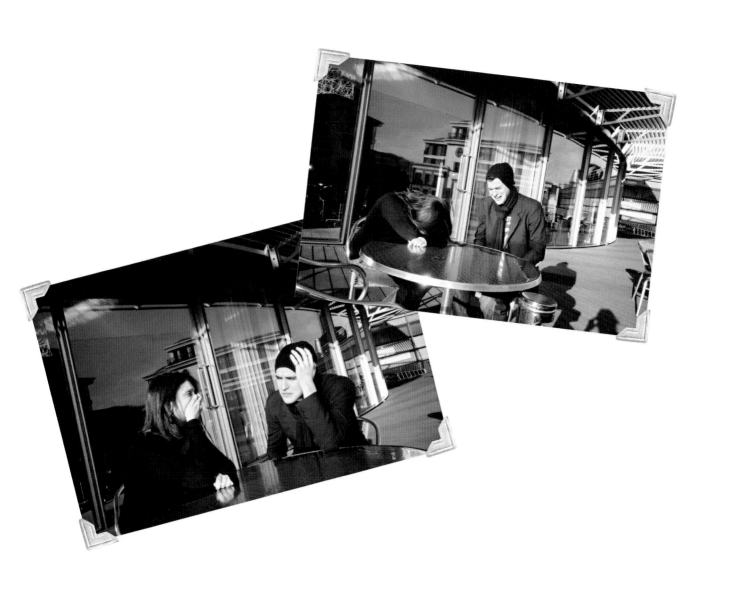

Shooters

Amanda Abbington, Rebecca Ackland, Jo Beasy, Tom Birkett, Kerry Bishop, Zoe Boarer-Pitman, Sarah Brotherton, Shelley Conn, Steven Cree, Paul Darkins, Mary Instone, Jennie Fava, Marisa Ferguson, Amelia Ferrand-Rook, Sarah Fitzpatrick, Gareth Flemyng, Dexter Fletcher, Emily Hallesy, Bea Holland, Deborah James, Jack Jefferson, Andrew Jubb, Aubrey K, Melanie Klein, Monica Macabe, Denis Madden, David Marsland, Sharon Palmer, Pearce Quigley, Tom Relph, Julian Rhind-Tutt, John Robertson, Klare Roger, Jamie Sives, Paul Starling, Adrian Storey, Tara Summers, Miriam Underhill, Christine Walmesley-Cotham, Kristi Warwick, Ann Wenn, Siva Zagel, that Nice Hungarian Bloke

Boyfriends

Richard Armitage, Nicholas Bailey, Hugh Bonneville, Paul Bradley, Gyles Brandreth, Ewen Bremner, David Burke, Kathy Burke, Oliver Chris, Martin Clunes, Christopher Colquhoun, Ben Daniels, Jack Davenport, Tim Downie, Graham Duff, Fish, Michael Fish, James Fleet, Jason Flemyng, Dexter Fletcher, Martin Freeman, Mark Frost, Steve Furst, George Galloway, Tristan Gemmill, Don Gilet, Iain Glen, Tom Goodman-Hill, John Hannah, Nigel Havers, Melvyn Hayes, Jake Humphrey, Rhys Ifans, Lennie James, Dom Joly, Steve Jones, Kevin Kennedy, Jonathan Kerrigan, Eric Knowles, Kwame Kwei-Armah, Burt Kwouk, James Lance, Mark Lawson, Stewart Lee, Ewen MacIntosh, Alastair Mackenzie, Howard Marks, Kris Marshall, Jake Maskall, Victor McGuire, Nick Miles, Stephen Moyer, Ardal O'Hanlon, Roger Lloyd Pack, Nathaniel Parker, Nicholas Parsons, Michael Portillo, Duncan Preston, Pearce Quigley, Vic Reeves, Julian Rhind-Tutt, Matthew Rhys, Tony Robinson, Jonathan Ryland, Simon Shepherd, Alexander Siddig, Hugo Speer, Jamie Theakston, Will Thorp, Stephen Tompkinson, Johnny Vegas, Bill Ward, Marc Warren, David Westhead, Shaun Williamson, Jonathan Wrather

Pimps

Matt Bardock, Helen Barratt, Clarissa Bromelle, Mark Byron, Lorna Cobbold, Lorna Gay Copp, Rosemary Davidson, Marisa Ferguson, Amelia Ferrand-Rook, Dexter Fletcher, Alan Frank, Sophie Gabszewicz, Alan 'King of Pimps' Gilchrist, Tom Goodman-Hill, Damien Goodwin, Damian Hayes, Nicky Hubbard, Stephen Kennedy, Monica Macabe, David Marsland, Laura McCann, Lucy McEwan, Nick Miles, Stephen Moyer, Sara Powell, Alexandra Pringle, Julian Rhind-Tutt, Klare Roger, George Richmond Scott, Jane Semark, Maris Sharp, Lucy Watson, David Westhead, Bob from the Pleasance

A huge, big thank you

Daniel Abelson, Jo Adamson, Rachel Alabaster, David Allen, Suzy Aplin, Suzi B, Matt Bardock, Desmond Barrit, Emma Basilico, Kate Beard, Tom Beard, Bench, Emma and John Bennett, Victoria Bensted, Louise Biddle, Katie Boreham, Robert Bowman, Lorraine Boyle, Emma Brocklehurst, Philippa Brockway, Charlotte Brown, Jo Brown, Stephen Bull, Susie Bullen, Dave Bussell, Millie Boo Butterworth, George Calil,

Vicky Camy, John Cannon, Jason Carey, Nick Chesterfield, Richard Clayton, Clarence Conway, Stiff Cooper, Gemma Cox, Liz Crabtree, Maddy Curtis, Alison Dale, Sarah Dalkin, Dulcie Danger, Gillian Dear, Geoff Deed, Elaine DeSaulles, Beverley Dixon, Sonja Dosanjh, Jeremy Dunn, Steve Elias, Amanda Evans, Ali Fellows, Sharon Finmark, Sarah Fitzpatrick, Jason Fitzpatrick, Jo Forshaw, Janet Gautrey, Lizz Gordon, Maddy Grant, Muireann Grealy, Ti Green, Suzanne Harris, Jon Hayward, Clare Hazeldine, Pea Horsley, Jo Howarth, Shaun Howarth, Nicky Hubbard, Peter Hunt, Sarah Hunt, Geoffrey Hutchings, Lovely Judi Hutchings, John Huyton, Mary Instone, Craig Irving, Erica Jarnes, Charlotte Jones, Barnaby Kay, James Keast, Jo Keating, Jacqui Kelly, Stephen Kennedy, John Khan, Suzy Kenway, Liz King, Martin King, Jo Kirkland, Maude Laflamme, Panda Leeds, Fiona Lindsay, Jerry Lindop, Adrian Lukis, Tamsin MacDonald, Maggie Mackay, Dominic Maffham, Julie Malooli, Tom Mannion, Sara Markland, Vicki McIvor, Stuart McQuarrie, Michaela and Greg Miles, Kirsty Milner, Sarah Moore, Jo Morton, Nicky Moss, Liz Nelson, Barney Newman, Greg Nye, Ellie O'Donnell, Jess O'Neill, Christine Osbourne, Manon Palmer, Jay Parsons, Matthew Paton, Christian Patterson, Diane Pender, Tom Relph, Phleds, Carol Reyes, Kate Richards, Cliona Roberts, Thirza Robinson, Justine Robson, Jenna Russell, Patrick Ryecart, Gabs Sanders, Malcolm Scates, Zoë Schoon, Gilly Schuster (the best agent), Spob, Susie Sefton, Susan and Hollie Shaper, Owen Sharpe, Nicky Sheppard, Warren Sherman, Romy Shiner, Penny Sims, Oliver Slinger, Kate Slocombe, Tim Smith, Tom Smith, Philippa Stanton, Philippa Stockton, Jeremy Stockwell, Kat Stonehouse, Charlie Swan, Joe Swift, Jane Tassell, Mat Taylor, Harry Teale, Sharon and Phil Thompson, Katie Tooke, Kt Vine, Francis Watson, Kate Watson, Becky Watts, Rob Wilfort, Chris Wilkinson, Niamh Yudt, Boner, Maria and Disco and the rest of my classmates, Mum and Rich, Affinity of Brighton, that lovely woman from the Assembly Rooms Press Office, Edinburgh, Barry at Richard of Church Street, Brighton, Bazaar, Hove, the BBC, the Boatman next to the RST, Christie's (your staff are lovely), the staff at Clapham Junction station, Jo at Conway Van Gelder, the boys and girls from the Dirty Duck in Stratford, Donmar Warehouse Theatre (you guys are top), Evolution, Brighton, GAFF, Brighton, the Hotel Pelirocco, Jessops, Brighton, Northbrook College, Worthing, the Old Vic, Pyramid, Brighton, Sandra, Trish and Barry – RSC Stage Door, Sole, Covent Garden, Tsena, Brighton, Tucan, Brighton, Velvet, Brighton, Villa and Hut, Brighton

Many thanks to all the long-suffering agents and their assistants who helped me

And of course to everyone at Bloomsbury who are superstars

And not forgetting all the Boyfriends – you guys rock

And last but certainly not least thank you to all the wives and partners who saw the funny side

And if I've missed anyone out, sorry, there'll be a pint waiting for you …

Liza Frank was born in Twickenham in the early seventies and spent most of her life mucking about in various theatres up and down the country. Bored, she left stage management and took a part time photography diploma at Northbrook College, Worthing. 'My Celebrity Boyfriend' was her graduation project. She lives in Brighton.

Hello there,

I've come up with an idea to ask famous men to pretend to be my boyfriend for a photograph. And I'd like you to help me.

Now before you chuck me into the weirdo/stalker/desperate bin you should know that I used to work in theatre so I'm quite savvy with the etiquette and don't touch, twitch or drool (and so far nobody's slapped me with a restraining order).

All that being my 'Celebrity Boyfriend' entails is posing for a photograph taken by a friend, my assistant or the self-timer, and convincing the viewer that we're a couple. You choose the location, the time, the pose and the length of the shoot. I'm happy to do anything as long as it'll make a good photo and have so far landed myself in bed, behind a bush, with a whip, as Edith Piaf, with a baby, cross dressing, and in a 1934 black and white film so anything goes (but please, no more rollercoasters).

So, are you game for an adventure? It's not every day you get an invitation like this.

All the best,
Liza Frank
The My Celebrity Boyfriend Project